ArtNotes

to accompany

History of Art
VOLUME I
REVISED SIXTH EDITION

H. W. Janson
Anthony F. Janson

PEARSON
Prentice
Hall

Upper Saddle River, New Jerse

© 2004 by PEARSON EDUCATION, INC.
Upper Saddle River, New Jersey 07458

10 9 8 7 6 5 4 3

ISBN 0-13-184310-9

Printed in the United States of America

Museum credits for fine art photos can be found with the images in the text. Images in the supplement were supplied by SuperStock, Inc. Please note that where we have included artwork in ArtNotes, we have made every effort to secure the same photograph of the art that is found in your text. There are some instances, however, where we had to substitute a slightly different photograph of an object. Please consult your textbook if you are studying the objects for identification purposes.

Contents

Chapter One
Prehistoric Art in Europe and North America

Notes

1-1. *Horses.* Cave painting. c. 28,000 B.C. *(page 38)*

1-2. *Wounded Bison.* Cave painting. c. 15,000–10,000 B.C. *(page 39)*

1-3. Axial Gallery, Lascaux. 15,000–10,000 B.C.
(page 39)

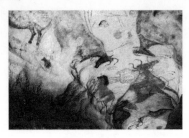

1-4. Schematic plan of Lascaux *(page 40)*

1-5. *Ritual Dance (?).* Rock engraving.
c. 10,000 B.C. *(page 40)*

1-6. *Horse,* from Vogelherd cave. c. 28,000 B.C.
(page 41)

1-7. *Woman of Willendorf.* c. 25,000–20,000 B.C.
(page 41)

1-8. *Bison,* from La Madeleine near Les Eyzies
(Dordogne). c. 15,000–10,000 B.C. *(page 41)*

1-9. Neolithic plastered skull, from Jericho.
c. 7000 B.C. *(page 42)*

1-10. Early Neolithic wall and tower, Jericho,
Jordan. c. 7000 B.C. *(page 42)*

1-11. *Animal Hunt.* Restoration of Main Room,
Shrine A.III.1, Çatal Hüyük (after Mellaart).
c. 6000 B.C. *(page 43)*

1-12. *Fertility Goddess,* from Shrine A.II.1, Çatal Hüyük. c. 6000 B.C. *(page 43)*

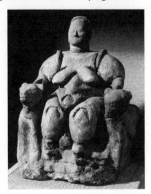

1-13. *View of Town and Volcano.* Wall painting, Shrine VII.14, Çatal Hüyük. c. 6000 B.C. *(page 43)*

1-14. Biconical vessels of the Tripole group, Ukraine. c. 3000 B.C. *(page 44)*

1-15. *Woman,* from Hluboké Masuvky, Moravia,
Czechoslovakia. c. 3000 B.C. *(page 44)*

1-16. Dolmen, Carnac (Brittany), France.
c. 1500 B.C. *(page 45)*

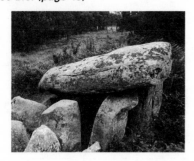

1-17. Stonehenge (aerial view), Salisbury Plain
(Wiltshire), England. c. 2000 B.C. *(page 45)*

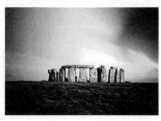

1-18. Stonehenge at sunset *(page 45)*

1-19. Diagram of original arrangement of stones at Stonehenge (after a drawing by Richard Tobias) *(page 45)*

1-20. Great Serpent Mound, Adams County, Ohio. c. 1070 A.D. *(page 46)*

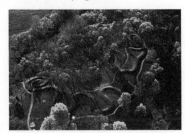

1-21. Cult Wagon, from Strettweg, Austria. 7th century B.C. *(page 47)*

1-22. Flagon, from Basse-Yutz, Lorraine region, France. 5th century B.C. *(page 47)*

Chapter Two
Egyptian Art

Notes

2-1, 2-2. *Palette of King Narmer* (both sides), from Hierakonpolis. c. 3150–3125 B.C. *(page 49)*

2-3. *Portrait Panel of Hesy-ra,* from Saqqara. c. 2660 B.C. *(page 51)*

2-4. Group of mastabas (after A. Badawy). 4th Dynasty *(page 51)*

2-5. Transverse section of the Step Pyramid of King Djoser, Saqqara *(page 52)*

2-6. Imhotep. Step Pyramid of King Djoser, Saqqara. 3rd Dynasty. c. 2681–2662 B.C. *(page 52)*

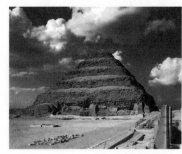

2-7. Plan of the funerary district of King Djoser, Saqqara (M. Hirmer after J. P. Lauer) (1) pyramid (m=mastaba); (2) funerary temple; (3, 4, 6) courts; (5) entrance hall; (7) small temple; (8) court of North Palace; (9) court of South Palace; (10) southern tomb *(page 53)*

2-8. Papyrus-shaped half-columns, North Palace, funerary district of King Djoser, Saqqara *(page 53)*

2-9. The Pyramids of Menkaure (c. 2533–2515
B.C.), Khafre (c. 2570–2544 B.C.), and Khufu
(c. 2601–2528 B.C.), Giza *(page 54)*

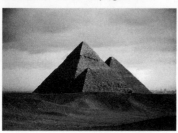

2-10. Plan of the pyramids at Giza: (1) Menkaure;
(2) Khafre; (3) Khufu *(page 54)*

2-11. North-south section of Pyramid of Khufu
(after L. Borchardt) *(page 54)*

2-12. The Great Sphinx, Giza. c. 2570–2544 B.C. *(page 55)*

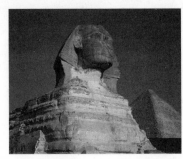

2-13. *Khafre,* from Giza. c. 2500 B.C. *(page 56)*

2-14. *Menkaure and His Wife, Queen Khamerernebty,* from Giza. c. 2515 B.C. *(page 57)*

2-15. *Prince Rahotep and His Wife, Nofret.*
c. 2580 B.C. *(page 57)*

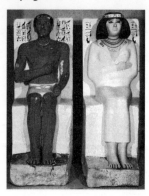

2-16. *Seated Scribe,* from Saqqara. c. 2400 B.C.
(page 58)

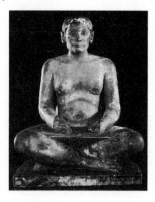

2-17. *Bust of Vizier Ankh-haf,* from Giza.
c. 2520 B.C. *(page 59)*

2-18. *Ti Watching a Hippopotamus Hunt.*
c. 2510–2460 B.C. *(page 59)*

2-19. *Portrait of Sesostris III* (fragment).
c. 1850 B.C. *(page 60)*

2-20. *Statue of the Lady Sennuwy.* c. 1920 B.C.
(page 61)

2-21. *Feeding the Oryxes.* c. 1928–1895 B.C. *(page 61)*

2-22. *Mai and His Wife, Urel.* Detail of a limestone relief. c. 1375 B.C. *(page 62)*

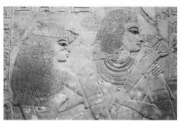

2-23. *A Pond in a Garden.* Fragment of a wall painting, from the Tomb of Nebamun, Thebes. c. 1400 B.C. *(page 62)*

2-24. *Musicians and Dancers,* fragment of a wall painting from the Tomb of Nebamun, Thebes. 1350 B.C. *(page 63)*

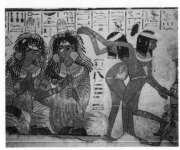

2-25. Temple of Queen Hatshepsut, Deir el-Bahri. c. 1478–1458 B.C. *(page 64)*

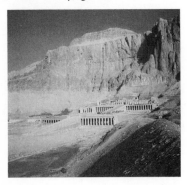

2-26. Reconstruction of temples, Deir el-Bahri, with temples of Mentuhotep II, Tuthmosis III, and Queen Hatshepsut (after a drawing by Andrea Mazzei/Archivio White Star, Vercelli, Italy) *(page 64)*

2-27. *Akhenaten and His Family.* c. 1355 B.C.
(page 65)

2-28. *Queen Nefertiti.* c. 1348–1336/5 B.C.
(page 65)

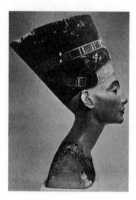

2-29. Cover of the coffin of Tutankhamen. 18th
Dynasty. *(page 66)*

2-30. *Workmen Carrying a Beam.* Detail of a relief, from the Tomb of Horemheb, Saqqara. c. 1325 B.C. *(page 66)*

2-31. *The Weighing of the Heart and Judgment of Osiris,* from The Book of the Dead of Hunefer. 1285 B.C. *(page 67)*

2-32. Court and pylon of Ramesses II (c. 1279–1212 B.C.) and colonnade and court of Amenhotep III (c. 1350 B.C.), temple complex of Amun-Mut-Khonsu, Luxor *(page 68)*

2-33. Pylon and court of Ramesses II, Temple
of Amun, Luxor. c. 1279–1212 B.C. *(page 68)*

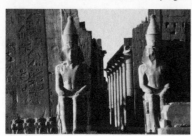

2-34. Plan of the Temple of Amun, Luxor (after
N. de Garis Davies) *(page 69)*

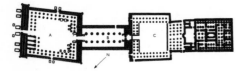

2-35. *Sety I's Campaigns,* Temple of Amun at
Karnak, Thebes (exterior wall, north side of
hypostyle). c. 1280 B.C. *(page 69)*

Chapter Three
Ancient Near Eastern Art

Notes

3-1. Remains of the "White Temple" on its ziggurat, Uruk (Warka), Iraq. c. 3500–3000 B.C. *(page 71)*

3-2. Plan of the "White Temple" on its ziggurat (after H. Frankfort) *(page 71)*

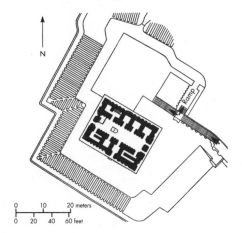

3-3. Interior of the cella of the "White Temple"
(page 71)

3-4. Ziggurat of King Urnammu, Ur (Muqaiyir),
Iraq. c. 2100 B.C. *(page 72)*

3-5. *Female Head,* from Uruk (Warka).
c. 3500–3000 B.C. *(page 72)*

3-6. Statues, from the Abu Temple, Tell Asmar,
Iraq. c. 2700–2500 B.C. *(page 73)*

3-7. *Ram and Tree.* Offering stand from Ur.
c. 2600 B.C. *(page 73)*

3-8. *Imdugud and Two Stags.* c. 2500 B.C.
(page 74)

3-9. Inlay panel from the soundbox of a harp, from Ur. c. 2600 B.C. *(page 74)*

3-10. *Standard of Ur,* front and back sides. c. 2600 B.C. *(page 75)*

3-11. *Priest-King Feeding Sacred Sheep,* from vicinity of Uruk (Warka). c. 3300 B.C. *(page 76)*

3-12. *Head of an Akkadian Ruler,* from Nineveh
(Kuyunjik), Iraq. c. 2300–2200 B.C. *(page 76)*

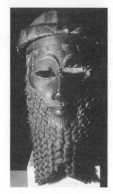

3-13. *Victory Stele of Naram-Sin.* c. 2254–2218 B.C.
(page 77)

3-14. *Gudea,* from Lagash (Telloh), Iraq.
c. 2120 B.C. *(page 78)*

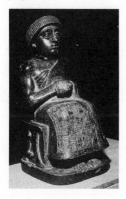

Notes

3-15. *Inanna-Ishtar.* c. 2025–1763 B.C. *(page 79)*

3-16. Upper part of stele inscribed with the Law Code of Hammurabi. c. 1760 B.C. *(page 80)*

3-17. The Lion Gate, Bogazköy, Anatolia, Turkey. c. 1400 B.C. *(page 80)*

3-18. *Kudurru (Boundary Stone) of Marduk-nadin-akhe.* 1099–1082 B.C. *(page 82)*

3-19. *Fugitives Crossing River,* from the Northwest Palace of Ashurnasirpal II, Nimrud (Calah), Iraq. c. 883–859 B.C. *(page 82)*

3-20. *Ashurnasirpal II Killing Lions,* from the Palace of Ashurnasirpal II, Calah (Nimrud), Iraq. c. 850 B.C. *(page 83)*

3-21. Gate of the Citadel of Sargon II, Dur Sharrukin (Khorsabad), Iraq (during excavation). 742–706 B.C. *(page 83)*

3-22. Ishtar Gate (restored), from Babylon, Iraq. c. 575 B.C. *(page 84)*

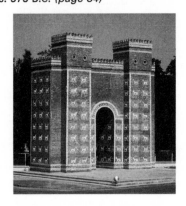

3-23. Painted beaker, from Susa. c. 5000–4000 B.C. *(page 85)*

3-24. Fragment of a belt, probably from
Ziwiye. Late 8th century B.C. *(page 85)*

3-25. Plan of the Palace of Darius and Xerxes,
Persepolis. 518–460 B.C. *(page 86)*

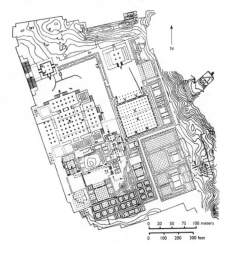

3-26. Audience Hall of Darius and Xerxes,
Persepolis, Iran. c. 500 B.C. *(page 87)*

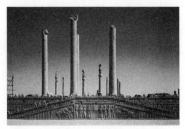

3-27. Bull capital, from Persepolis. c. 500 B.C.
(page 87)

3-28. *Darius and Xerxes Giving Audience.*
c. 490 B.C. *(page 88)*

3-29. Rhyton. Achaemenid. 5th–3rd centuries B.C.
(page 88)

3-30. *Shapur I Triumphing over the Roman Emperors Philippus the Arab and Valerian.* A.D. 260–72. *(page 89)*

3-31. Palace of Shapur I, Ctesiphon, Iraq. 242–72 A.D. *(page 90)*

3-32. *King Peroz I* (457–483) *Hunting Gazelles.* Late 5th century A.D. *(page 91)*

Chapter Four
Aegean Art

4-1. Figure, from Amorgos, Cyclades. c. 2500 B.C. *(page 93)*

4-2. *Harpist,* so-called Orpheus, from Amorgos, Cyclades. Latter part of the 3rd millennium B.C. *(page 94)*

4-3. Plan of the Palace of Minos, Knossos, Crete. The palace is organized in two wings, to the east and west of a central court, and is on several levels. (1) stairway and theater area (2) storerooms (3) central court (4) antechamber (5) corridor of the procession (6) throne room (7) north pillar hall (8) hall of the colonnade (9) hall of the double axes (10) queen's megaron (11) queen's bath (12) entrances and atriums *(page 95)*

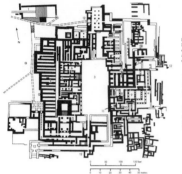

Plan of the Palace of Minos, Knossos, Crete. The palace is organized in two wings, to the east and west of a central court, and is on several levels:

1) stairway and theater area
2) storerooms
3) central court
4) antechamber
5) corridor of the procession
6) throne room
7) north pillar hall
8) hall of the colonnade
9) hall of the double axes
10) queen's megaron
11) queen's bath
12) entrances and atriums

4-4. Staircase, east wing, Palace of Minos, Knossos, Crete. c. 1500 B.C. *(page 96)*

4-5. The Queen's Megaron, Palace of Minos, Knossos, Crete. c. 1700–1300 B.C. *(page 96)*

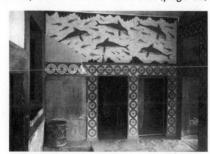

4-6 *"Snake Goddess,"* from the palace complex, Knossos. c. 1650 B.C. *(page 97)*

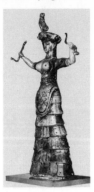

4-7. Rhyton in the shape of a bull's head, from Knossos. c. 1500–1450 B.C. *(page 97)*

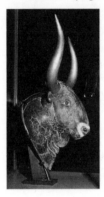

4-8. *Crocus Girl* (left) and *"The Mistress of the Animals"* (right). Mural fragments from Akrotiri, Thera (Santorini). c. 1670–1620 B.C. *(page 98)*

4-9. *Landscape.* Fresco from Akrotiri, Thera. c. 1600–1500 B.C. *(page 99)*

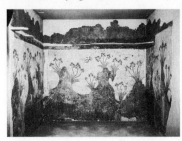

4-10. *"The Toreador Fresco,"* from the palace complex, Knossos. c. 1500 B.C. (restored). *(page 99)*

4-11. Beaked jug (Kamares style), from Phaistos. c. 1800 B.C. *(page 100)*

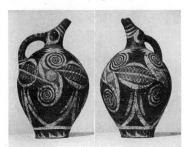

4-12. *"Octopus Vase,"* from Palaikastro, Crete.
c. 1500 B.C. *(page 100)*

4-13. *Harvester Vase,* from Hagia Triada.
c. 1500–1450 B.C. *(page 101)*

4-14. Interior, Treasury of Atreus, Mycenae,
Greece. c. 1300–1250 B.C. *(page 101)*

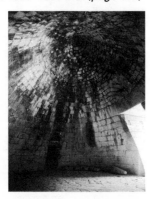

4-15. Section, Treasury of Atreus *(page 101)*

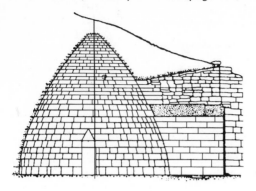

4-16. Rhyton in the shape of a lion's head, from a shaft grave at Mycenae. c. 1550 B.C. *(page 102)*

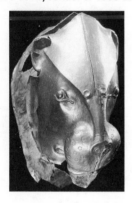

4-17, 4-18. *Vaphio Cups.* c. 1500–1450 B.C. *(page 103)*

4-19. The Lioness Gate, Mycenae, Greece. 1250 B.C. *(page 104)*

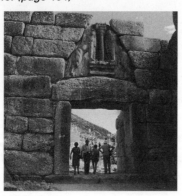

4-20. Plan of a Mycenaean megaron *(page 105)*

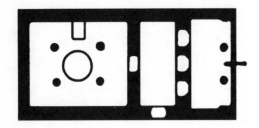

4-21. *Three Deities*, from Mycenae. 14th–13th century B.C. (page 105)

Chapter Five
Greek Art

5-1. Some common Greek vessel forms
(page 107)

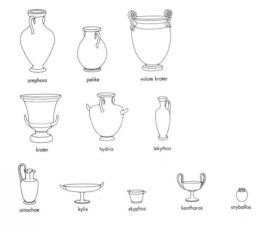

5-2. *Dipylon Vase* from the Dipylon cemetery, Athens. 8th century B.C. *(page 108)*

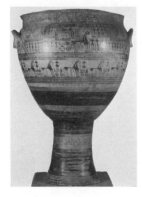

5-3. *The Blinding of Polyphemos and Gorgons,*
on a Proto-Attic amphora. c. 675–650 B.C.
(page 109)

5-4. Proto-Corinthian perfume vase. c. 650 B.C.
(page 110)

5-5. Exekias. *Dionysos in a Boat.* Interior of an
Attic black-figured kylix c. 540 B.C. *(page 112)*

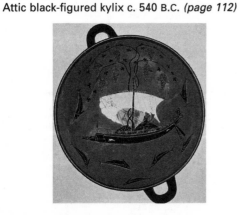

5-6. Psiax. *Herakles Strangling the Nemean Lion,* on an Attic black-figured amphora from Vulci, Italy. c. 525 B.C. *(page 113)*

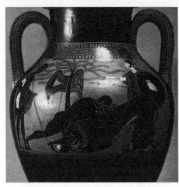

BOX. The Prononomos Painter. *Dionysos and Ariadne Amidst Players and Characters of the Theater.* End of 5th century b.c. Volute krater. National Museum, Naples *(page 114)*

5-7. Euphronios. *Herakles Wrestling Antaios,* on an Attic red-figured krater. c. 510 B.C. *(page 115)*

5-8. Douris. *Eos and Memnon.* Interior of an Attic red-figured kylix. c. 490–480 B.C. *(page 115)*

5-9. *Female Figure (Kore).* c. 650 B.C. *(page 117)*

5-10. *Kouros (Standing Youth).* c. 600 B.C. *(page 117)*

Notes

5-11. *Kroisos (Kouros from Anavysos).* c. 525 B.C.
(page 118)

5-12. *Calf-Bearer.* c. 570 B.C. *(page 118)*

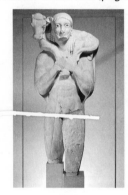

5-13. *"Hera,"* from Samos. c. 570–560 B.C.
(page 119)

5-14. Head. c. 525–550 B.C. *(page 119)*

5-15. *Kore in Dorian Peplos,* known as *Peplos Kore.* c. 530 B.C. *(page 120)*

5-16. *Kore,* from Chios (?). c. 520 B.C. *(page 120)*

5-17. Central portion of the west pediment of the Temple of Artemis at Corfu, Greece. c. 600–580 B.C. *(page 121)*

5-18. Reconstruction drawing of the west front of the Temple of Artemis at Corfu (after Rodenwaldt) *(page 121)*

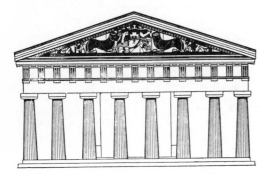

5-19. Plan of the Treasury of the Siphnians *(page 122)*

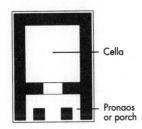

Cella

Pronaos
or porch

5-20. Reconstruction drawing of the Treasury of the Siphnians. Sanctuary of Apollo at Delphi. c. 525 B.C. *(page 122)*

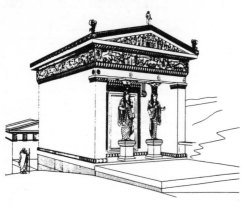

5-21. *Battle of the Gods and Giants,* from the north frieze of the Treasury of the Siphnians, Delphi. c. 530 B.C. *(page 123)*

5-22. Reconstruction drawing of the east pediment of the Temple of Aphaia, Aegina (after Ohly) *(page 123)*

5-23. *Dying Warrior,* from the east pediment of the Temple of Aphaia. c. 480 B.C. *(page 124)*

5-24. *Herakles,* from the east pediment of the Temple of Aphaia. c. 480 B.C. *(page 124)*

5-25. Doric, Ionic, and Corinthian orders, respectively *(page 125)*

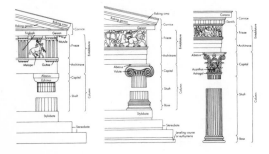

5-26. Ground plan of a typical Greek peripteral temple (after Grinnell) *(page 125)*

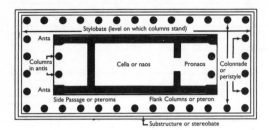

5-27. The Temple of Hera I ("Basilica"), c. 550 B.C., and the Temple of Hera II ("Temple of Poseidon"), c. 460 B.C. Paestum *(page 127)*

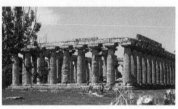

5-28. Corner of the Temple of Hera I, Paestum, Italy. c. 550 B.C. *(page 128)*

5-29. Interior, Temple of Hera II. c. 500 B.C. *(page 129)*

5-30. Sectional view (restored) of the Temple of Aphaia, Aegina *(page 129)*

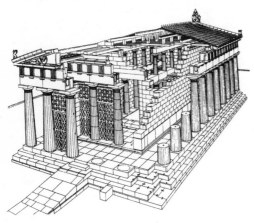

5-31. Iktinos, Kallikrates, and Karpion. The Parthenon (view from the west), Akropolis, Athens. 448–432 B.C. *(page 130)*

5-32. Plan of the Akropolis at Athens in 400 B.C.
(after A. W. Lawrence) *(page 131)*

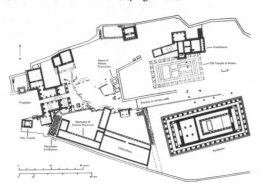

5-33. Frieze above the western entrance of the
cella of the Parthenon *(page 131)*

5-34. Mnesikles. The Propylaea, 437–432 B.C.
Akropolis (view from the west, inside the
grounds), Athens *(page 132)*

5-35. The Propylaea, 437–432 B.C.; with Temple of Athena Nike, 427–424 B.C., Akropolis (view from the west), Athens *(page 133)*

5-36. Temple of Athena Nike (view from the east), Akropolis, Athens, 421–405 B.C. *(page 133)*

5-37. Aeolian capital, from Larissa. c. 600 B.C. *(page 134)*

5-38. Porch of the Maidens, the Erechtheum, Akropolis, Athens. 421–405 B.C. *(page 134)*

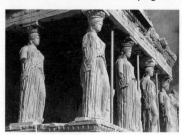

5-39. Corinthian capital, from the Tholos at Epidauros. c. 350 B.C. *(page 134)*

5-40. Monument of Lysikrates, Athens, c. 334 B.C. *(page 135)*

5-41. Theater, Epidauros. c. 350 B.C. *(page 136)*

5-42. Plan of the Theater, Epidauros (after Picard-Cambridge) *(page 136)*

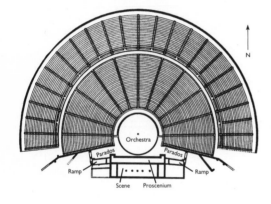

5-43. *Kritios Boy.* c. 480 B.C. *(page 137)*

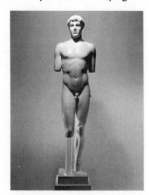

5-44. *Doryphoros (Spear Bearer).* Roman copy after an original of c. 450–440 B.C. by Polykleitos. *(page 138)*

BOX. The Pistoxenos Painter. *Linos and Iphikles at Music Lesson.* c. 470 B.C. Attic red-figured drinking cup *(skyphos).* Staatliches Museum, Schwerin, Germany *(page 139)*

5-45. Riace Warrior A, found in the sea off Riace, Italy. c. 450 B.C. *(page 141)*

5-46. Riace Warrior B, found in the sea off
Riace. c. 450 B.C. *(page 141)*

5-47. *Charioteer,* from the Sanctuary of Apollo
at Delphi. c. 470 B.C. *(page 142)*

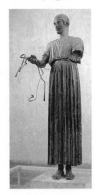

5-48. Ze*us.* c. 460–450 B.C. *(page 143)*

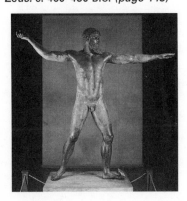

5-49. *Diskobolos (Discus Thrower).* Roman marble copy after a bronze original of c. 450 B.C. by Myron. *(page 144)*

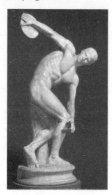

5-50. Photographic reconstruction (partial) of the *Battle of the Lapiths and Centaurs,* from the west pediment of the Temple of Zeus at Olympia. c. 460 B.C. *(page 145)*

5-51. *Atlas Bringing Herakles the Apples of the Hesperides.* c. 456 B.C. *(page 145)*

Notes

5-52. *Dying Niobid.* c. 450–440 B.C. *(page 146)*

5-53. *Dionysos,* from the east pediment of the Parthenon. c. 438–432 B.C. *(page 147)*

5-54. *Three Goddesses,* from the east pediment of the Parthenon. c. 438–432 B.C. *(page 147)*

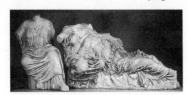

5-55. Jacques Carrey. Drawings of the east pediment of the Parthenon. 1674. *(page 147)*

5-56. *Horsemen,* from the west frieze of the Parthenon. c. 488–432 B.C. *(page 148)*

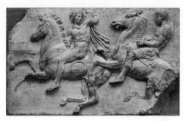

5-57. *The Sacrifice of King Erechtheus' Daughters* (?), from the east frieze of the Parthenon. c. 440 B.C. *(page 148)*

5-58. *Lapith and Centaur,* metope from the south side of the Parthenon. c. 440 B.C. *(page 149)*

5-59. *Nike,* from the balustrade of the Temple of Athena Nike. c. 410–407 B.C. *(page 149)*

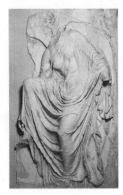

5-60. *Grave Stele of Hegeso.* c. 410–400 B.C. *(page 150)*

5-61. *The Abduction of Proserpine.* Detail of a wall painting in Tomb I, Vergina, Macedonia. c. 340–330 B.C. *(page 150)*

5-62. *The Battle of Issos* or *Battle of Alexander and the Persians.* c. 100 B.C. Mosaic copy from Pompeii of a Hellenistic painting of c. 315 B.C. *(page 151)*

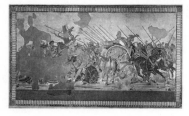

5-63. The Achilles Painter. *Muse and Maiden,* on an Attic white-ground lekythos. c. 440–430 B.C. *(page 152)*

5-64. The Marsyas Painter. *Peleos and Thetis,* on a Kerch-style pelike. c. 340 B.C. *(page 152)*

5-65. Reconstruction drawing of the Mausoleum at Halikarnassos. 359–351 B.C. *(page 153)*

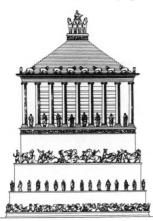

5-66. Skopas (?). *Battle of the Greeks and Amazons,* from the east frieze of the Mausoleum, Halikarnassos. 359–351 B.C. *(page 154)*

5-67. *"Mausolos,"* from the Mausoleum at Halikarnassos. c. 360 B.C. *(page 154)*

5-68. *Demeter,* from Knidos. c. 330 B.C. *(page 155)*

5-69. *Knidian Aphrodite.* Roman copy after an original of c. 340–330 B.C. by Praxiteles. *(page 155)*

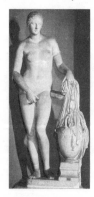

5-70. *Hermes.* Roman copy after an original of c. 320–310 B.C. by Praxiteles. *(page 156)*

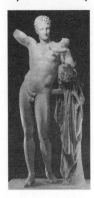

5-71. *Apollo Belvedere.* Roman marble copy, probably of a Greek original of the late 4th century B.C. *(page 156)*

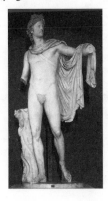

5-72. *Apoxyomenos (Scraper).* Roman marble copy, probably after a bronze original of c. 330 B.C. by Lysippos. *(page 157)*

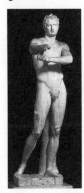

5-73. Epigonos of Pergamon (?). *Dying Trumpeter.* Perhaps a Roman copy after a bronze original of c. 230–220 B.C., from Pergamon, Turkey. *(page 158)*

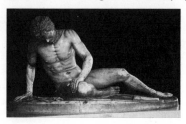

5-74. The west front of the Great Pergamon Altar (restored). Staatliche Museen zu Berlin, Preussischer Kulturbesitz, Antikensammlung *(page 158)*

5-75. Plan of the Great Pergamon Altar (after J. Schrammen) *(page 158)*

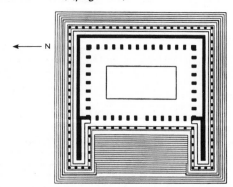

5-76. *Athena and Alkyoneus,* from the east side of the Great Frieze of the Great Pergamon Altar. c. 166–156 B.C. *(page 159)*

5-77. Pythokritos of Rhodes (?). *Nike of Samothrace.* c. 190 B.C. *(page 161)*

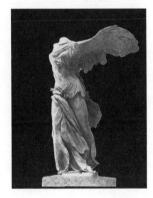

5-78. *The Laocoön Group.* Perhaps by Agesander, Athenodoros, and Polydoros of Rhodes (present state, former restorations removed). 1st century B.C. *(page 162)*

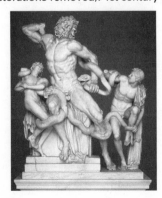

5-79. *Portrait Head,* from Delos. c. 80 B.C.
(page 163)

5-80. *Veiled Dancer.* c. 200 B.C.? *(page 163)*

5-81. *Winged God.* Silver coin from Peparethos.
c. 500 B.C. *(page 165)*

5-82. *Silenus.* Silver coin from Naxos, Sicily.
c. 460 B.C. *(page 165)*

5-83. *Apollo.* Silver coin from Catana.
c. 415–400 B.C. *(page 165)*

5-84. *Alexander the Great with Amun Horns.*
Four-drachma silver coin issued by
Lysimachos. c. 297–281 B.C. *(page 165)*

Notes

5-85. *Antimachos of Bactria.* Silver coin. c. 185 B.C.
(page 165)

Chapter Six
Etruscan Art

Notes

6-1. Human-headed cinerary urn. c. 675–650 B.C.
(page 166)

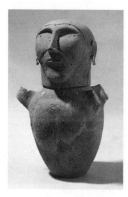

6-2. Sarcophagus, from Cerveteri. c. 520 B.C.
(page 167)

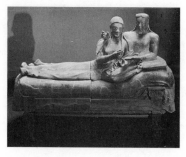

Notes

6-3. Tomb of Hunting and Fishing, Tarquinia, Italy. c. 520 B.C. *(page 168)*

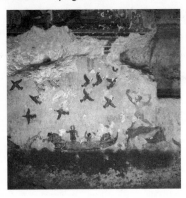

6-4. *Musicians and Two Dancers.* Detail of a wall painting. c. 470–460 B.C. Tomb of the Lionesses, Tarquinia, Italy *(page 169)*

6-5. *Youth and Demon of Death.* Cinerary container. Early 4th century B.C. *(page 170)*

6-6. Burial chamber. Tomb of the Reliefs,
Cerveteri, Italy. 3rd century B.C. *(page 170)*

6-7. Reconstruction of an Etruscan temple, as
described by Vitruvius. Museo delle Antichità
Etrusche e Italiche, Università di Roma "La
Sapienza" *(page 171)*

6-8. *Apollo,* from Veii. c. 510 B.C. *(page 171)*

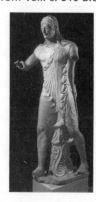

6-9. *She-Wolf.* c. 500 B.C. *(page 172)*

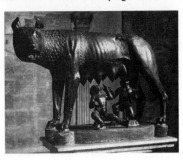

6-10. *Portrait of a Boy.* Early 3rd century B.C. *(page 173)*

6-11. Engraved back of a mirror. c. 400 B.C. *(page 173)*

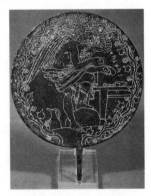

6-12. Sarcophagus lid of Larth Tetnies and
Thanchvil Tarnai. c. 350–300 B.C. *(page 174)*

Chapter Seven
Roman Art

7-1. Arch, barrel vault, and groin vault *(page 177)*

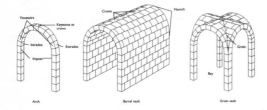

7-2. "Temple of Fortuna Virilis," Rome. Late 2nd century B.C. *(page 178)*

7-3. Plan of the "Temple of Fortuna Virilis"
(page 178)

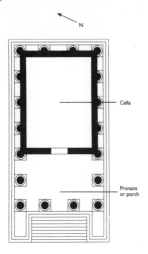

Cella

Pronaos
or porch

7-4. "Temple of the Sibyl," Tivoli. Early 1st
century B.C. *(page 178)*

7-5. Plan of the "Temple of the Sibyl"
(page 178)

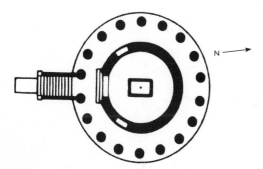

7-6. Sanctuary of Fortuna Primigenia, Praeneste (Palestrina). Early 1st century B.C. *(page 179)*

7-7. Axonometric reconstruction of the Sanctuary of Fortuna Primigenia, Praeneste *(page 179)*

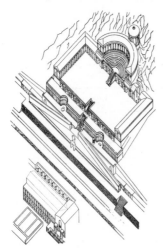

7-8. Plan of the Forums, Rome: (1) Temple of Capitoline Jupiter; (2) Temple of Trajan; (3) Basilica Ulpia; (4) Market of Trajan; (5) Temple of Venus Genetrix; (6) Forum of Trajan; (7) Temple of Mars Ultor; (8) Forum of Augustus; (9) Forum of Julius Caesar; (10) Senate Chamber; (11) Temple of Concord; (12) Roman Forum; (13) Sacred Way; (14) Basilica Julia; (15) Temple of Castor and Pollux; (16) Arch of Augustus; (17) Temple of Vesta; (18) Temple of Julius Caesar; (19) Basilica Aemilia; (20) Temple of Antoninus and Faustina; (21) House of the Vestal Virgins; (22) Temple of Romulus; (23) Basilica of Maxentius and Constantine; (24) Forum of Vespasian; (25) Temple of Minerva; (26) Forum of Nerva *(page 180)*

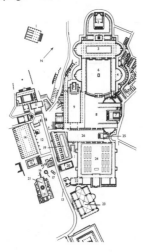

7-9. Pont du Gard, Nîmes, France. Early 1st century A.D. *(page 181)*

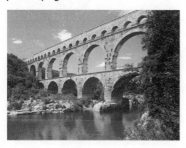

7-10. The Colosseum (aerial view), Rome. 72–80 A.D. *(page 181)*

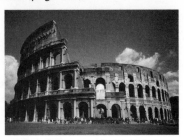

7-11. View of the outer wall of the Colosseum *(page 182)*

7-12. Giovanni Paolo Panini. *The Interior of the Pantheon.* c. 1740. *(page 182)*

7-13. Plan of the Pantheon *(page 183)*

7-14. Transverse section of the Pantheon *(page 183)*

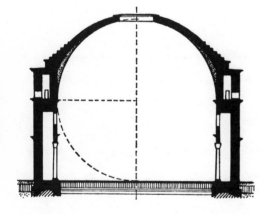

7-15. The Pantheon, Rome. 118–25 A.D. *(page 183)*

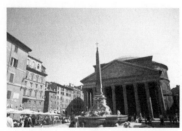

7-16. Basilica, Leptis Magna, Libya. Early 3rd century A.D. *(page 184)*

7-17. Plan of the Basilica, Leptis Magna *(page 184)*

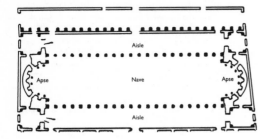

7-18. The Basilica of Constantine, Rome. c. 307–20 A.D. *(page 185)*

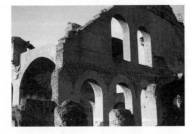

7-19. Reconstruction drawing of the Basilica of Constantine (after Huelsen) *(page 185)*

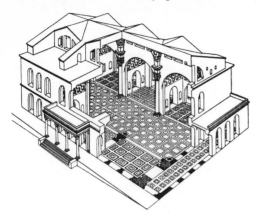

7-20. Plan of the Basilica of Constantine *(page 185)*

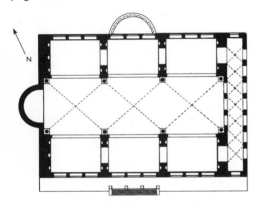

7-21. Atrium, House of the Silver Wedding, Pompeii. Early 1st century A.D. *(page 186)*

7-22. Insula of the House of Diana, Ostia. c. 150 A.D. *(page 186)*

7-23. Market Gate from Miletus (restored). c. 160 A.D. Staatliche Museen zu Berlin, Preussischer Kulturbesitz, Antikensammlung *(page 187)*

7-24. Peristyle, Palace of Diocletian, Spalato, Croatia. c. 300 A.D. *(page 188)*

7-25. *Aulus Metellus (L'Arringatore).* Early 1st century B.C. *(page 189)*

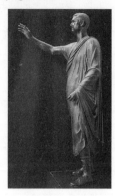

7-26. *A Roman Patrician with Busts of His Ancestors.* Late 1st century B.C. *(page 189)*

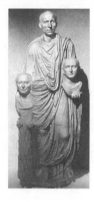

7-27. *Augustus of Primaporta.* Roman copy of c. 20 A.D. of a Roman original of c. 15 B.C. *(page 190)*

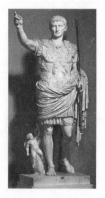

7-28. *Augustus of Primaporta.* Detail of breast-plate *(page 191)*

7-29. *Vespasian.* c. 75 A.D. *(page 192)*

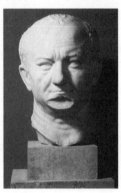

7-30. *Trajan.* c. 100 A.D. *(page 192)*

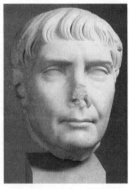

7-31. Ara Pacis. c. 13–9 B.C. *(page 193)*

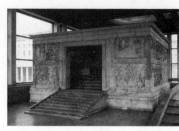

7-32. *Imperial Procession,* a portion of the frieze of the Ara Pacis. 13–9 B.C. *(page 193)*

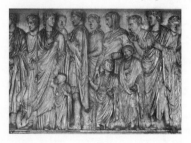

7-33. *Procession,* a portion of the east frieze, Parthenon. c. 440 B.C. *(page 193)*

7-34. Allegorical and ornamental panels of the Ara Pacis *(page 194)*

7-35. *Spoils from the Temple in Jerusalem.* Relief in passageway, Arch of Titus, Rome. 81 A.D. *(page 194)*

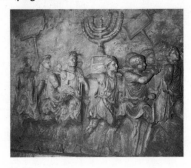

7-36. *Triumph of Titus.* Relief in passageway, Arch of Titus *(page 195)*

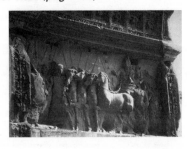

7-37. Lower portion of the Column of Trajan, Rome. 106–13 A.D. *(page 196)*

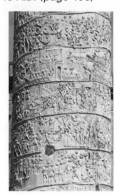

7-38. *Apotheosis of Sabina.* 136–38 A.D. *(page 197)*

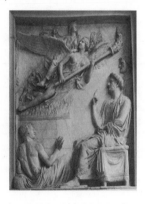

7-39. *Meleager Sarcophagus.* c. 180 A.D. *(page 197)*

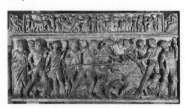

Notes

7-40. *Equestrian Statue of Marcus Aurelius.*
161–80 A.D. *(page 198)*

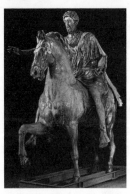

7-41. *Faustina the Younger.* c. 147–48 A.D.
(page 198)

7-42. *Philippus the Arab.* 244–49 A.D. *(page 199)*

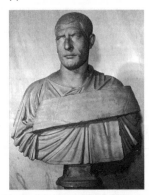

7-43. *Portrait Head* (probably Plotinus). Late
3rd century A.D. *(page 199)*

7-44. *The Tetrarchs.* c. 305 A.D. *(page 200)*

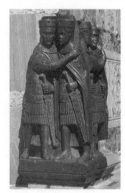

7-45. *Constantine the Great.* Early 4th century A.D.
(page 200)

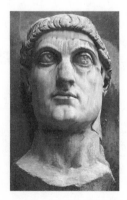

7-46. Arch of Constantine, Rome. 312–15 A.D.
(page 201)

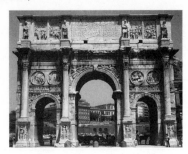

7-47. Medallions (117–38 A.D.) and frieze (early 4th century), Arch of Constantine *(page 202)*

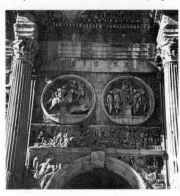

7-48. *Architectural View.* Wall painting from a villa at Boscoreale, near Naples. 1st century B.C. *(page 203)*

7-49. *The Laestrygonians Hurling Rocks at the Fleet of Odysseus.* Wall painting from the Odyssey Landscapes series in a house on the Esquiline Hill, Rome. Late 1st century B.C. *(page 204)*

7-50. *View of a Garden.* Wall painting from the Villa of Livia at Primaporta. c. 20 B.C. Museo delle Terme, Rome *(page 204)*

7-51. *Scenes of a Dionysiac Mystery Cult.* Mural frieze. c. 50 B.C. Villa of the Mysteries, Pompeii *(page 205)*

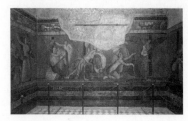

7-52. The Ixion Room, House of the Vettii, Pompeii. 63–79 A.D. *(page 206)*

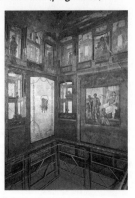

BOX. *Scene from New Comedy* (traveling musicians). 2nd century B.C.*(page 207)*

7-53. *Peaches and Glass Jar.* Wall painting from Herculaneum. c. 50 A.D. *(page 208)*

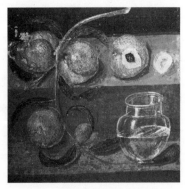

7-54. *Hercules and Telephus.* Wall painting from Herculaneum. c. 70 A.D. Museo Archeologico Nazionale, Naples *(page 209)*

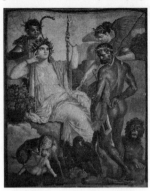

7-55. *Portrait of a Boy,* from the Faiyum, Lower Egypt. 2nd century A.D. *(page 209)*

Chapter Eight
Early Christian and Byzantine Art

Notes

8-1. *Mithras Slaying the Sacred Bull.* c. 150–200 A.D. *(page 229)*

8-2. *The Consecration of the Tabernacle and Its Priests,* from the Assembly Hall of the Synagogue at Dura-Europos. 245–56 A.D. *(page 230)*

8-3. Painted ceiling. 4th century A.D. *(page 231)*

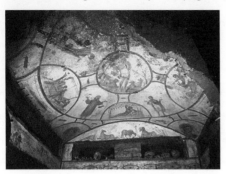

8-4. Plan of Old St. Peter's (after Frazer)
(page 233)

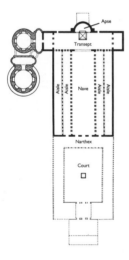

8-5. Jacopo Grimaldi. *Facade of St. Peter's, Rome.* 1619. *(page 233)*

8-6. Jacopo Grimaldi. *Interior of Old St. Peter's, Rome.* 1619. *(page 233)*

8-7. Interior, Sta. Costanza, Rome. c. 350 A.D. *(page 234)*

8-8. Plan of Sta. Costanza *(page 235)*

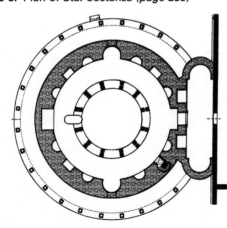

8-9. Section of Sta. Costanza *(page 235)*

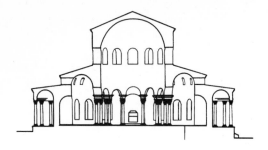

8-10. S. Lorenzo Maggiore, Milan, exterior
from the southeast. c. 388–91 A.D. *(page 235)*

8-11. Interior, S. Lorenzo Maggiore *(page 236)*

Notes

8-12. Plan of S. Lorenzo Maggiore (after Krautheimer) *(page 236)*

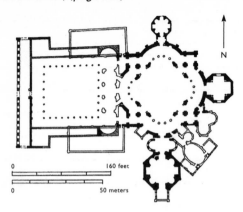

0 160 feet

0 50 meters

8-13. S. Apollinare in Classe, Ravenna, Italy. 533–49 A.D. *(page 237)*

8-14. Plan of S. Apollinare in Classe (after De Angelis d'Ossat) *(page 237)*

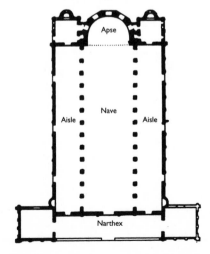

8-15. Interior (view toward the apse),
S. Apollinare in Classe, Ravenna. 533–49 A.D.
(page 237)

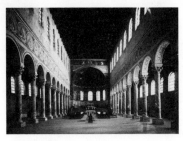

8-16. *Good Shepherd.* 425–50. *(page 238)*

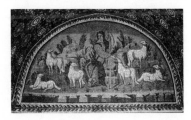

8-17. *The Parting of Lot and Abraham.* c.
432–40 A.D. *(page 239)*

8-18. *The Betrayal of Christ.* c. 500 A.D. *(page 240)*

8-19. Miniature, from the *Vatican Vergil.* Early 5th century A.D. *(page 242)*

8-20. Page with *Jacob Wrestling the Angel,* from the *Vienna Genesis.* Early 6th century A.D. *(page 243)*

8-21. *Sarcophagus of Junius Bassus.* c. 359 A.D.
(page 244)

8-22. *Priestess of Bacchus.* Leaf of a diptych.
c. 390–400 A.D. *(page 245)*

8-23. *Portrait of Eutropios.* c. 450 A.D.
(page 245)

8-B1. *The Entry into Jerusalem,* from the
Codex Purpureus. 6th century. *(page 246)*

8-24. S. Vitale, Ravenna. 526–47 A.D. *(page 248)*

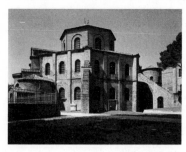

8-25. Plan of S. Vitale *(page 248)*

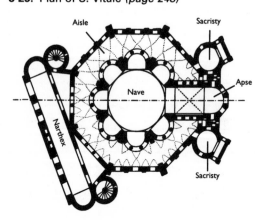

8-26. Transverse section of S. Vitale *(page 248)*

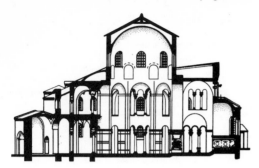

8-27. Interior (view from the apse into the choir), S. Vitale *(page 248)*

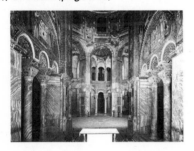

8-28. *Emperor Justinian and His Attendants.* c. 547 A.D. *(page 249)*

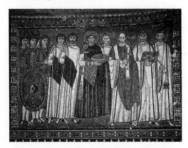

8-29. *Empress Theodora and Her Attendants.*
c. 547 A.D. *(page 249)*

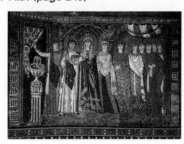

8-30. Section of Hagia Sophia (after Gurlitt)
(page 250)

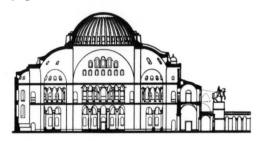

8-31. Plan of Hagia Sophia (after v. Sybel)
(page 250)

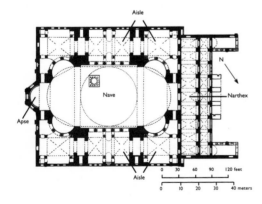

8-32. Parts of a dome *(page 250)*

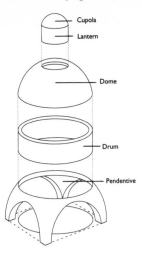

8-33. Anthemius of Tralles and Isidorus of Miletus. Hagia Sophia, Istanbul, Turkey. 532–37 A.D. *(page 250)*

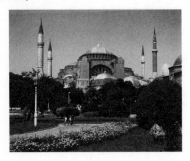

8-34. Interior, Hagia Sophia *(page 251)*

8-35. Capital, Hagia Sophia *(page 252)*

8-36. *The Archangel Michael.* Leaf of a diptych.
Early 6th century A.D. *(page 253)*

8-37. *Throne of Maximianus.* c. 547. *(page 253)*

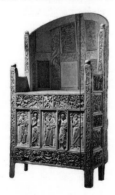

8-38. *Justinian As Conqueror.* c. 525–50 A.D.
(page 254)

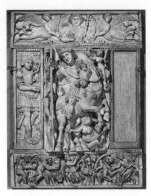

8-39. *Virgin and Child Enthroned between Saints and Angels.* Late 6th century A.D. *(page 255)*

8-40. *Virgin and Child Enthroned.* c. 843–67.
(page 256)

8-41. Churches of the Monastery of Hosios Loukas (St. Luke of Stiris), Greece. Early 11th century *(page 257)*

8-42. Plan of churches of the Monastery of Hosios Loukas (after Diehl) *(page 258)*

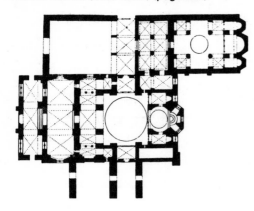

8-43. Interior, Katholikon, Hosios Loukas *(page 258)*

8-44. *Nativity.* Early 11th century. *(page 258)*

8-45. St. Mark's (aerial view), Venice. Begun 1063 *(page 259)*

8-46. Interior, St. Mark's, Venice *(page 259)*

8-47. Cathedral of St. Basil, Moscow. 1554–60
(page 260)

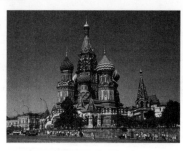

8-48. *David Composing the Psalms,* from the
Paris Psalter. c. 900 A.D. *(page 261)*

8-49. *The Crucifixion.* 11th century. *(page 262)*

8-50. Dome mosaics. 11th century. *(page 263)*

8-51. *Lamentation.* 1164. *(page 264)*

8-52. *Christ in the Garden of Gethsemane.*
c. 1183. *(page 265)*

8-53. *The Harbaville Triptych.* Late 10th century.
(page 265)

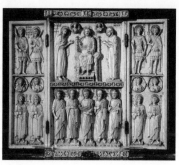

8-54. *The Veroli Casket.* 10th century. *(page 266)*

8-55. *Madonna Enthroned.* Late 13th century.
(page 267)

8-56. *Elizabeth at the Well.* c. 1310. *(page 268)*

8-57. *Anastasis.* c. 1310–20. *(page 269)*

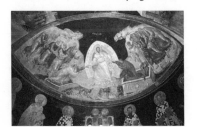

Chapter Nine
Early Medieval Art

9-1. Purse cover, from the Sutton Hoo ship burial. 625–33 A.D. *(page 271)*

9-2. *Animal Head,* from the Oseberg ship burial. c. 825 A.D. *(page 271)*

9-3. Cross page, from the *Lindisfarne Gospels.*
c. 700 A.D. *(page 272)*

9-4. Chi Rho page, from the *Book of Kells.*
c. 800 A.D.? *(page 273)*

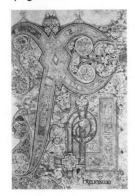

9-5. *Symbol of St. Mark,* from the *Echternach
Gospels.* c. 690 A.D. *(page 274)*

9-6. *Crucifixion,* plaque from a book cover (?).
8th century A.D. *(page 275)*

9-7. Balustrade relief inscribed by the Patriarch
Sigvald (762–76 A.D.), probably carved c.
725–50 A.D. *(page 275)*

9-8. Entrance, Palace Chapel of Charlemagne,
Aachen, Germany. 792–805 A.D. *(page 277)*

9-9. Interior of the Palace Chapel of Charlemagne, Aachen *(page 278)*

9-10. Cross section of the Palace Chapel of Charlemagne (after Kubach) *(page 278)*

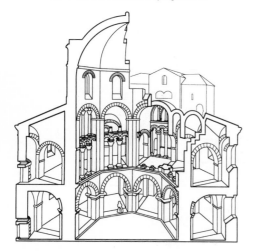

9-11. Facade, Abbey Church, Corvey, Germany. Late 9th century A.D., with later additions *(page 279)*

9-12. Western Tribune, Abbey Church, Corvey *(page 279)*

9-13. Plan of a monastery. Redrawn, with inscriptions translated into English from the Latin, from the original of c. 820 A.D. *(page 280)*

9-14. Sta. Maria de Naranco, Oviedo, Spain. Dedicated 848 A.D. *(page 281)*

9-15. *St. Matthew,* from the *Gospel Book of Charlemagne.* c. 800–10 A.D. *(page 281)*

9-16. *Portrait of Menander.* c. 70 A.D. *(page 282)*

9-17. *St. Mark,* from the *Gospel Book of Archbishop Ebbo of Reims.* 816–35 A.D. *(page 282)*

9-18. Illustrations to Psalms 43 and 44, from the *Utrecht Psalter*. c. 820–32 A.D. *(page 283)*

9-19. Front cover of binding, *Lindau Gospels.* c. 870 A.D. *(page 284)*

9-20. *The Gero Crucifix.* c. 975–1000 A.D. *(page 286)*

9-21. Westwork, St. Pantaleon, Cologne.
Consecrated 980 A.D. *(page 287)*

9-22. Reconstructed plan, Hildesheim Cathedral
(St. Michael's), Germany. 1001–33 A.D. (after Beseler)
(page 287)

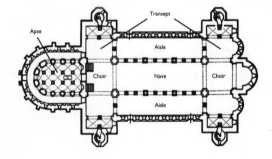

9-23. Reconstructed longitudinal section,
Hildesheim Cathedral (after Beseler) *(page 287)*

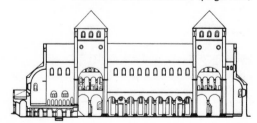

9-24. Interior (view toward the apse, after restoration of 1950–60), Hildesheim Cathedral *(page 288)*

9-25. Doors of Bishop Bernward. 1015 A.D. *(page 290)*

9-26. *Adam and Eve Reproached by the Lord,* from the Doors of Bishop Bernward. *(page 291)*

9-27. *Jesus Washing the Feet of Peter,* from the *Gospel Book of Otto III.* c. 1000 A.D. *(page 292)*

9-28. *St. Luke,* from the *Gospel Book of Otto III.* c. 1000 A.D. *(page 293)*

9-29. *Moses Receiving the Law* and *The Doubting of Thomas.* Early 11th century. *(page 293)*

Chapter Ten
Romanesque Art

Notes

10-1. St.-Sernin, Toulouse, France (aerial view).
c. 1070–1120 *(page 296)*

10-2. Plan of St.-Sernin (after Conant) *(page 296)*

10-3. Nave and choir, St.-Sernin *(page 297)*

10-4. Nave wall, Autun Cathedral, France. c. 1120–32 *(page 297)*

10-5. South Transept, Cluny III, 1088–1130 *(page 298)*

10-6. Choir (c. 1060–75) and nave (1095–1115),
St.-Savin-sur-Gartempe, France *(page 298)*

10-7. West facade, Notre-Dame-la-Grande,
Poitiers, France. Early 12th century *(page 298)*

BOX. The cloister at Sto. Domingo de Silos
Monastery, Spain. c. 1085–1100 *(page 299)*

10-8. West facade, St.-Étienne, Caen, France. Begun 1068 *(page 301)*

10-9. Nave (looking east), Durham Cathedral, England. 1093–1130 *(page 301)*

10-10. Plan of Durham Cathedral (after Conant) *(page 302)*

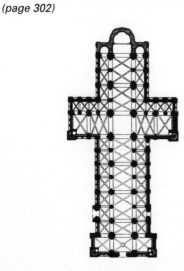

10-11. Transverse section of Durham Cathedral (after Acland) *(page 302)*

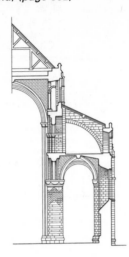

10-12. Rib vaults (after Acland) *(page 302)*

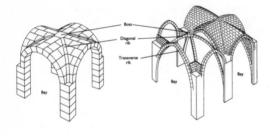

10-13. Nave (vaulted c. 1115–20), St.-Étienne, Caen *(page 303)*

10-14. Speyer Cathedral, Germany, from the east. Begun 1030 *(page 303)*

10-15. S. Ambrogio, Milan. Late 11th and 12th centuries *(page 304)*

10-16. Interior, S. Ambrogio *(page 304)*

Notes

10-17. Pisa Baptistery, Cathedral, and Campanile (view from the west). 1053–1272 *(page 305)*

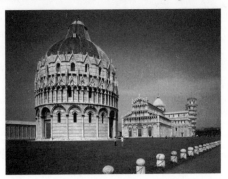

10-18. Interior, Pisa Cathedral *(page 306)*

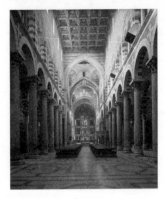

10-19. Baptistery of S. Giovanni, Florence. c. 1060–1150 *(page 306)*

10-20. *Apostle.* c. 1090. *(page 307)*

10-21. South portal (portion), St.-Pierre, Moissac, France. Early 12th century *(page 307)*

10-22. Romanesque and High Gothic portal ensembles *(page 308)*

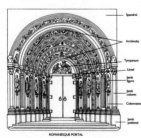

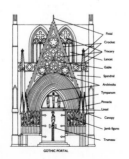

10-23. East flank, south portal, St.-Pierre, Moissac (the angel of the *Annunciation,* bottom left, is modern) *(page 309)*

10-24. Giselbertus. *Last Judgment,* west tympanum, Autun Cathedral. c. 1130–35 *(page 309)*

10-25. Giselbertus. *Eve,* right half of lintel, north portal from Autun Cathedral, France. 1120–1132. *(page 310)*

10-26. *The Mission of the Apostles,* tympanum of center portal of narthex, Ste.-Madeleine, Vézelay, France. 1120–32 *(page 310)*

10-27. North jamb, center portal, St.-Gilles-du-Gard, France. Second quarter of the 12th century *(page 311)*

10-28. *The Doubting of Thomas.* c. 1130–40. *(page 312)*

10-29. Wiligelmo. *Scenes from Genesis.* c. 1106–20.
(page 313)

10-30. Benedetto Antelami. *King David.* c. 1180–90.
(page 313)

10-31. Renier of Huy. Baptismal Font. 1107–18.
(page 314)

10-32. Lion Monument. 1166. *(page 314)*

10-33. Ewer. Mosan. c. 1130. *(page 315)*

10-34. *St. Mark,* from a Gospel Book produced at Corbie. c. 1050. *(page 315)*

10-35. *The Battle of Hastings.* Detail of the *Bayeux Tapestry.* c. 1073–83. *(page 316)*

10-36. *The Building of the Tower of Babel.* Detail of painting on the nave vault, St.-Savin-sur-Gartempe, France. Early 12th century *(page 317)*

10-37. *The Arrest of Christ.* c. 1085. *(page 317)*

BOX. *"The Fountain of Life,"* detail from
Liber divornum operum Vision 8. fol. 132r.
13th century. *(page 318)*

10-38. *St. John the Evangelist,* from the *Gospel
Book of Abbot Wedricus.* c. 1147. *(page 319)*

10-39. *Portrait of a Physician,* from a medical
treatise. c. 1160. *(page 319)*

10-40. Nicholas of Verdun. *Klosterneuburg Altar.* 1181. *(page 320)*

10-41. Nicholas of Verdun. *The Crossing of the Red Sea,* from the *Klosterneuburg Altar.* 1181. *(page 320)*

10-42. Page with *Summer Landscape,* from a manuscript of *Carmina Burana.* Early 13th century. *(page 321)*

Chapter Eleven
Gothic Art

Notes

11-1. Ambulatory, Abbey Church of St.-Denis, Paris. 1140–44 *(page 323)*

11-2. Plan of the choir and ambulatory of St.-Denis (Peter Kidson) *(page 323)*

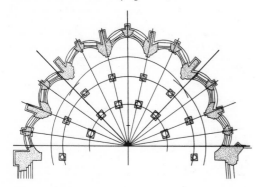

11-3. Jean Colombe. *King Priam Rebuilding Troy*
(detail), detached miniature from *Histoire de la
destruction de Troie la Grande*, after 1490. *(page 325)*

11-4. Plan of Notre-Dame, Paris. 1163–c. 1250
(page 326)

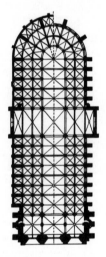

11-5. Nave and choir, Notre-Dame *(page 326)*

11-6. Notre-Dame (view from the southeast)
(page 326)

11-7. Flying arches and flying buttresses,
Notre-Dame *(page 327)*

11-8. West facade, Notre-Dame *(page 327)*

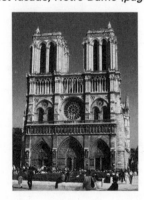

BOX. Maˆtre aux Bouqueteaux. *Guillaume de Machaut in His Study (Amour Presenting Him to His Three Children).* 1370. A miniature from an illuminated manuscript page of Machaut's works, fol. D. Bibliothèque Nationale, Paris *(page 328)*

11-9. West facade, Chartres Cathedral (north spire is from 16th century). 1145–1220 *(page 329)*

11-10. Chartres Cathedral *(page 330)*

11-11. Portals, north transept, Chartres
Cathedral (see also fig. 11-43) *(page 330)*

11-12. Transverse section of Chartres Cathedral
(after Acland) *(page 331)*

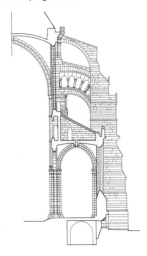

11-13. Nave and choir, Chartres Cathedral
(page 331)

11-14. Plan, Chartres Cathedral *(page 331)*

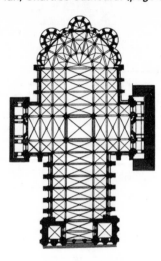

11-15. Triforium wall of the nave, Chartres Cathedral *(page 332)*

11-16. Choir vault, Amiens Cathedral. Begun 1220 *(page 333)*

11-17. Nave and side aisle, Amiens Cathedral *(page 334)*

11-18. Comparison of nave elevations in same scale (after Grodecki) (1) Notre-Dame, Paris (2) Chartres Cathedral (3) Reims Cathedral (4) Amiens Cathedral *(page 334)*

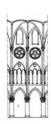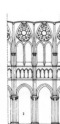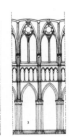

11-19. Axonometric projection of a High Gothic cathedral (after Acland) (1) Bay (2) Nave (3) Side aisle (4) Nave arcade (5) Triforium (6) Clerestory (7) Pier (8) Compound pier (9) Sexpartite vault (10) Buttress (11) Flying buttress (12) Flying arch (13) Roof *(page 335)*

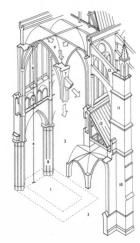

11-20. West facade, Reims Cathedral. c. 1225–99
(page 335)

11-21. St.-Urbain, Troyes, France. 1261–75
(page 336)

11-22. Interior toward northeast, St.-Urbain
(page 336)

11-23. St.-Maclou, Rouen, France. Begun 1434
(page 337)

11-24. Salisbury Cathedral, England. 1220–70
(page 338)

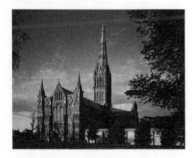

11-25. Plan of Salisbury Cathedral *(page 338)*

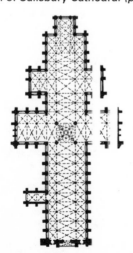

11-26. Nave and choir, Salisbury Cathedral
(page 338)

11-27. Choir, Gloucester Cathedral, England.
1332–57 *(page 339)*

11-28. Chapel of Henry VII (view toward west),
Westminster Abbey, London. 1503–19 *(page 339)*

11-29. Diagram of vault construction, Chapel of Henry VII, Westminster Abbey (after Swaan) *(page 339)*

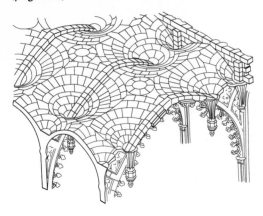

11-30. Choir, Heiligenkreuz, Schwäbish-Gmünd, Germany. After 1351 *(page 340)*

11-31. Plan of the Abbey Church of Fossanova *(page 341)*

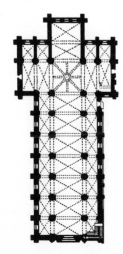

11-32. Nave and choir, Abbey Church of
Fossanova, Italy. Consecrated 1208 *(page 341)*

11-33. Nave and choir, Sta. Croce, Florence.
Begun c. 1295 *(page 342)*

11-34. Plan of Sta. Croce *(page 342)*

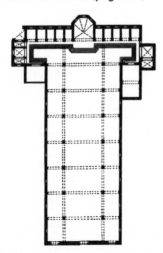

11-35. Florence Cathedral (Sta. Maria del Fiore).
Begun by Arnolfo di Cambio, 1296; dome by Filippo
Brunelleschi, 1420–36 *(page 343)*

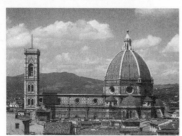

11-36. Plan of Florence Cathedral and Campanile
(page 343)

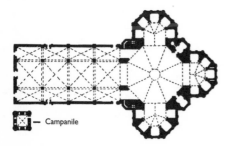

— Campanile

11-37. Bernardino Poccetti. Drawing of Arnolfo di
Cambio's unfinished design for the facade of
Florence Cathedral. c. 1587. *(page 344)*

11-38. Nave and choir, Florence Cathedral
(page 344)

11-39. Palazzo Vecchio, Florence. Begun 1298
(page 345)

11-40. Ca' d'Oro, Venice. 1422–c. 1440
(page 345)

11-41. West portal, Chartres Cathedral. c. 1145–70
(page 346)

11-42. Jamb statues, west portal, Chartres
Cathedral *(page 347)*

11-43. *Coronation of the Virgin* (tympanum),
Dormition and Assumption of the Virgin (lintel),
north portal, Chartres Cathedral. c. 1230 *(page 348)*

11-44. Jamb statues, south transept portal, Chartres Cathedral. c. 1215–20 *(page 348)*

11-45. *Death of the Virgin*, tympanum of the south transept portal, Strasbourg Cathedral, France. C. 1220. *(page 349)*

11-46. *Annunciation* and *Visitation,* west portal, Reims Cathedral. c. 1225–45 *(page 350)*

11-47. *Melchizedek and Abraham,* interior west
wall, Reims Cathedral. After 1251 *(page 350)*

11-48. *The Virgin of Paris.* Early 14th century.
(page 351)

11-49. *Signs of the Zodiac* and *Labors of the
Months (July, August, September),* west facade,
Amiens Cathedral. c. 1220–30 *(page 351)*

11-50. Tomb of a Knight. c. 1260. *(page 352)*

11-51. *Crucifixion,* on the choir screen, Naumburg Cathedral, Germany. c. 1240–50. *(page 352)*

11-52. *The Kiss of Judas,* on the choir screen, Naumburg Cathedral. c. 1240–50. *(page 353)*

11-53. *Ekkehard and Uta.* c. 1240–50. *(page 353)*

11-54. *Roettgen Pietà.* Early 14th century. *(page 353)*

11-55. Claus Sluter. Portal of the Chartreuse de Champmol, Dijon, France. 1385–93. *(page 354)*

11-56. Claus Sluter. *The Moses Well.* 1395–1406. *(page 355)*

11-57. Nicola Pisano. Pulpit. 1259–60. *(page 355)*

11-58. *Nativity,* detail of the pulpit by Nicola Pisano *(page 356)*

11-59. *Fortitude,* detail of the pulpit by Nicola Pisano *(page 356)*

11-60. Giovanni Pisano. *The Nativity,* detail of pulpit. 1302–10. *(page 357)*

11-61, 11-62. Giovanni Pisano. *Madonna.* c. 1315. *(page 357)*

11-63. *Equestrian Statue of Can Grande della Scala,* from his tomb. 1330. *(page 358)*

11-64. Arnolfo di Cambio. Tomb of Guglielmo de Braye. 1282. *(page 359)*

11-65. Lorenzo Ghiberti. *The Sacrifice of Isaac.* 1401–2. *(page 360)*

11-66. Andrea da Pisano. *The Baptism of Christ,* from the south doors, Baptistery of S. Giovanni, Florence. 1330–36. *(page 360)*

11-67. *Notre Dame de la Belle Verrière.* c. 1170. *(page 361)*

11-68. Villard de Honnecourt. *Wheel of Fortune.* c. 1240. *(page 362)*

11-69. Villard de Honnecourt. *Front View of a Lion.* c. 1240. *(page 362)*

11-70. *Nahash the Ammonite Threatening the Jews at Jabesh,* from the *Psalter of St. Louis.* c. 1260. *(page 363)*

11-71. Master Honoré. *David and Goliath,* from the *Prayer Book of Philip the Fair.* 1295. *(page 364)*

11-72. Cimabue. *Madonna Enthroned.* c. 1280–90. *(page 365)*

11-73. Duccio. *Madonna Enthroned,* center of the *Maestà Altar.* 1308–11. *(page 365)*

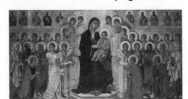

11-74. Duccio. *Annunciation of the Death of the Virgin,* from the *Maestà Altar (page 366)*

11-75. Duccio. *Christ Entering Jerusalem,* from the back of the *Maestà Altar.* 1308–11. *(page 366)*

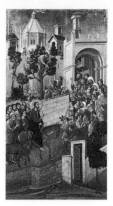

11-76. Pietro Cavallini. *Seated Apostles,* from *The Last Judgment.* c. 1290. *(page 367)*

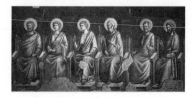

11-77. Interior, Arena (Scrovegni) Chapel. 1305–6 *(page 368)*

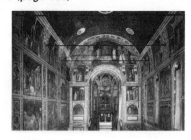

11-78. Giotto. *Christ Entering Jerusalem.* 1305–6. *(page 369)*

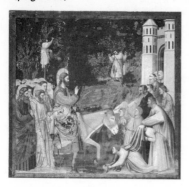

11-79. Giotto. *The Lamentation.* 1305–6. *(page 369)*

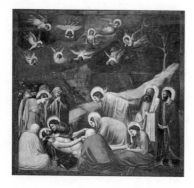

11-80. Giotto. *Madonna Enthroned.* c. 1310. *(page 370)*

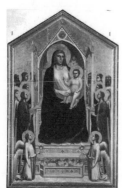

11-81. Simone Martini. *The Road to Calvary.* c. 1340. *(page 371)*

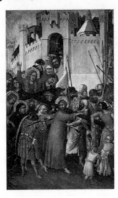

11-82. Pietro Lorenzetti. *Birth of the Virgin.* 1342. *(page 372)*

11-83. Ambrogio Lorenzetti. *The Commune of Siena* (left), *Good Government in the City,* and portion of *Good Government in the Country* (right). 1338–40. *(page 372)*

11-84. Ambrogio Lorenzetti. *Good Government in the City (page 373)*

11-85. Ambrogio Lorenzetti. *Good Government in the Country (page 373)*

11-86. Francesco Traini(?). *The Triumph of Death* (detail). c. 1325–50. *(page 374)*

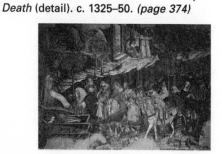

11-87. Francesco Traini. Sinopia drawing for *The Triumph of Death* (detail). Camposanto, Pisa *(page 375)*

11-88. Maso di Banco (attr.) (left) and Taddeo Gaddi (right). Tombs of Members of the Bardi Family. c. 1335–45 and c. 1335–41. *(page 376)*

11-89. Jean Pucelle. *The Betrayal of Christ* and *Annunciation,* from the *Hours of Jeanne d'Evreux.* 1325–28. *(page 377)*

11-90. Bohemian Master. *Death of the Virgin.* 1355–60. *(page 378)*

11-91. Melchior Broederlam. *Annunciation and Visitation; Presentation in the Temple;* and *Flight into Egypt.* 1394–99. *(page 379)*

11-92. Jean Malouel and Henri Bellechose. *Martyrdom of St. Denis with the Trinity.* c. 1415. *(page 379)*

11-93. The Boucicaut Master. *The Story of Adam and Eve,* from Giovanni Boccaccio, *Des cas des nobles hommes et femmes* (The Fates of Illustrious Men and Women). Paris c. 1415. *(page 380)*

11-94. The Limbourg Brothers. *October,* from *Les Très Riches Heures du Duc de Berry.* 1413–16. *(page 380)*

11-95. Konrad von Soest. *The Wildunger Altarpiece.* 1403? *(page 381)*

11-96. Master Francke. *Christ Carrying the Cross,* from the *Englandfahrer Altarpiece.* 1424. *(page 381)*

11-97. Gentile da Fabriano. *The Adoration of the Magi.* 1423. *(page 382)*

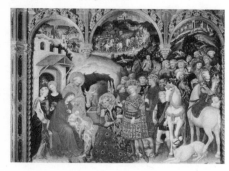

11-98. Gentile da Fabriano. *The Nativity,* from the predella of *The Adoration of the Magi.* 1423. *(page 383)*